Cartoon Creator

By Drew Froese

HAVE FUN!!!!

This is a book of cartooning fun! You get to create fun faces and people, combining whichever features you desire. My hope is that this will help you love to draw, will create a lot of laughter, and will bring you joy for years to come!

How to use this book:

Use the pages throughout this book to combine features to create wacky, fun, funny, serious, mad, happy, or whatever type of cartoon you want. Start with a body, then add the head, then start putting on the features. You may need to tilt your paper to get the features to fit just right, or you may want the features to look really wierd and put them in the wrong place
(use a nose for the ears) that's okay too.
Really, it's about creativity and fun, so enjoy.

This book is dedicated to:
Amy, Makenna, Bailey, Bryce, and Adeline
I love you so much!!!!!

Bodies

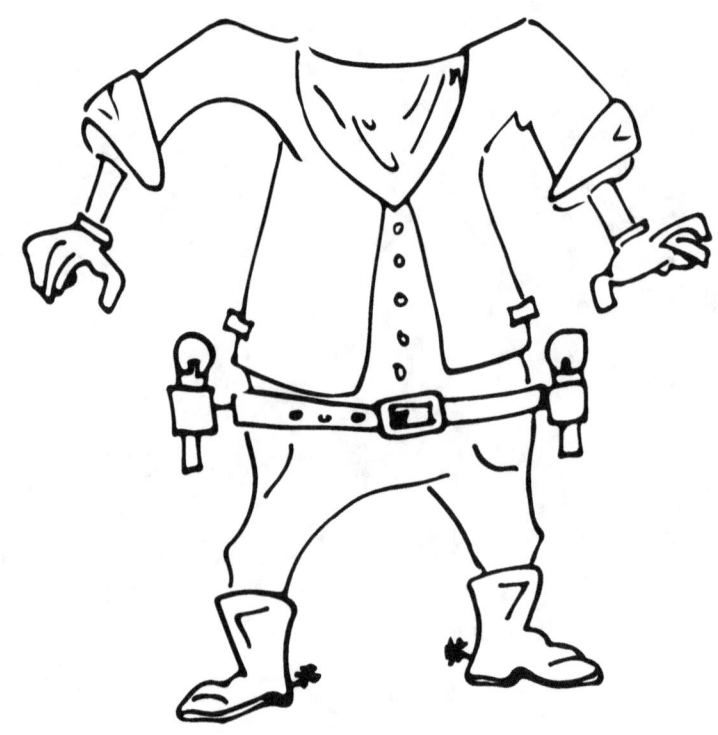

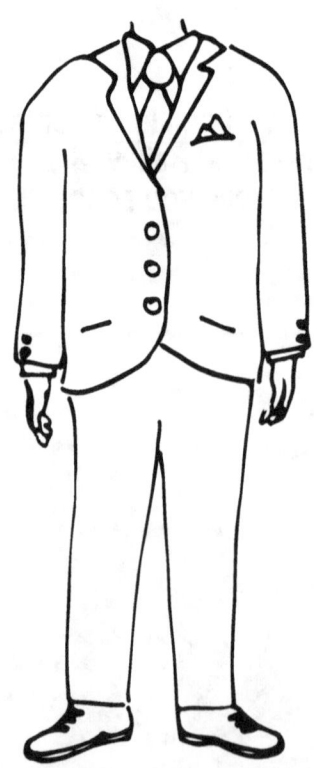

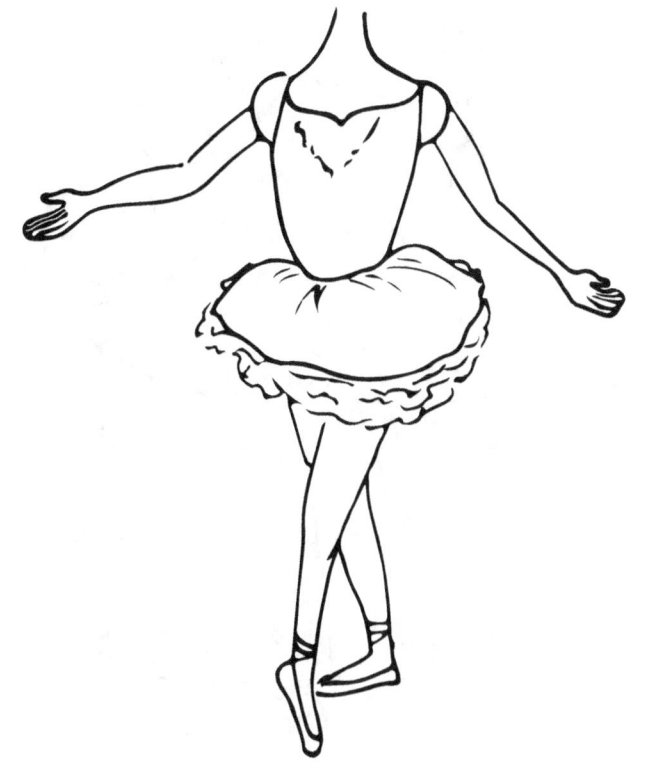

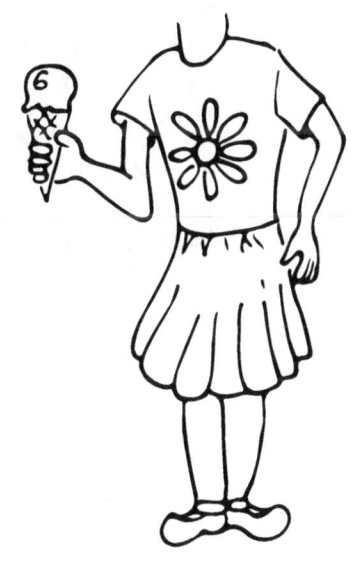

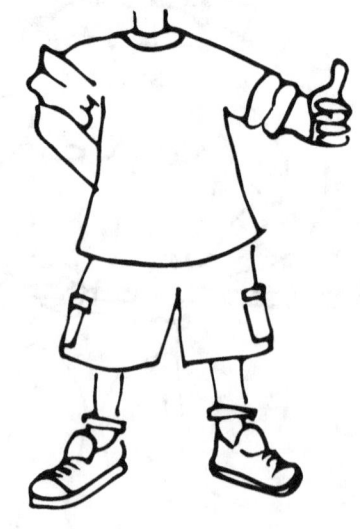
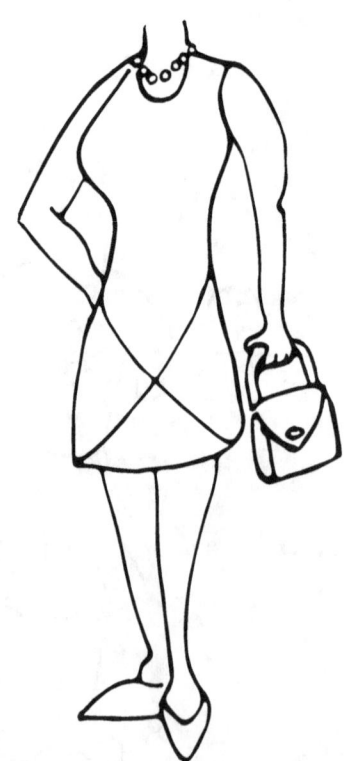

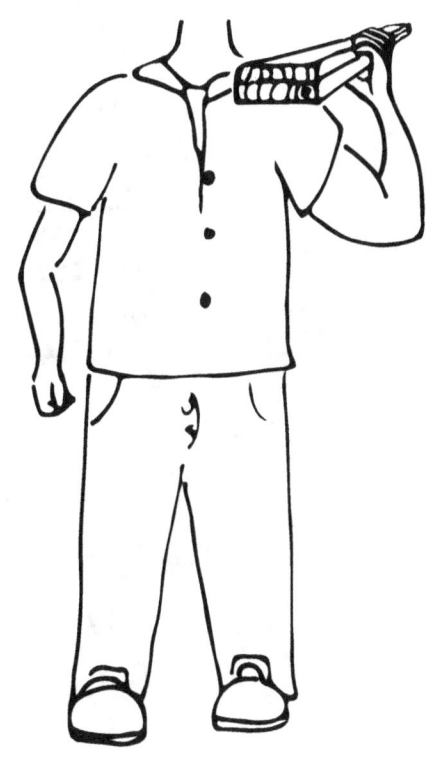

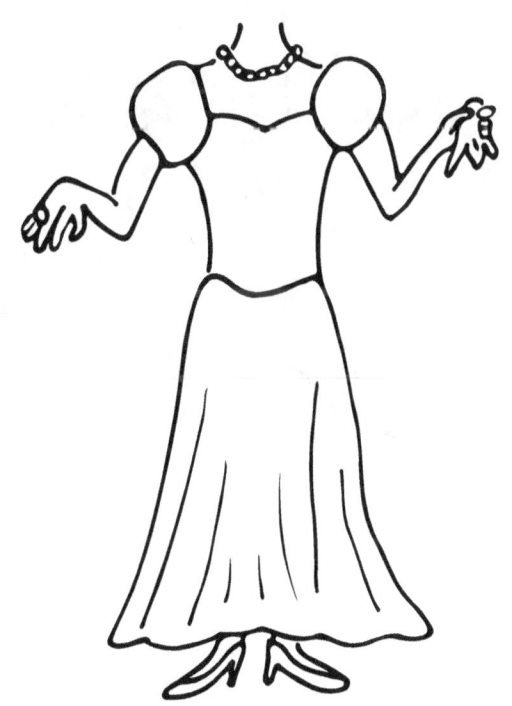

Heads

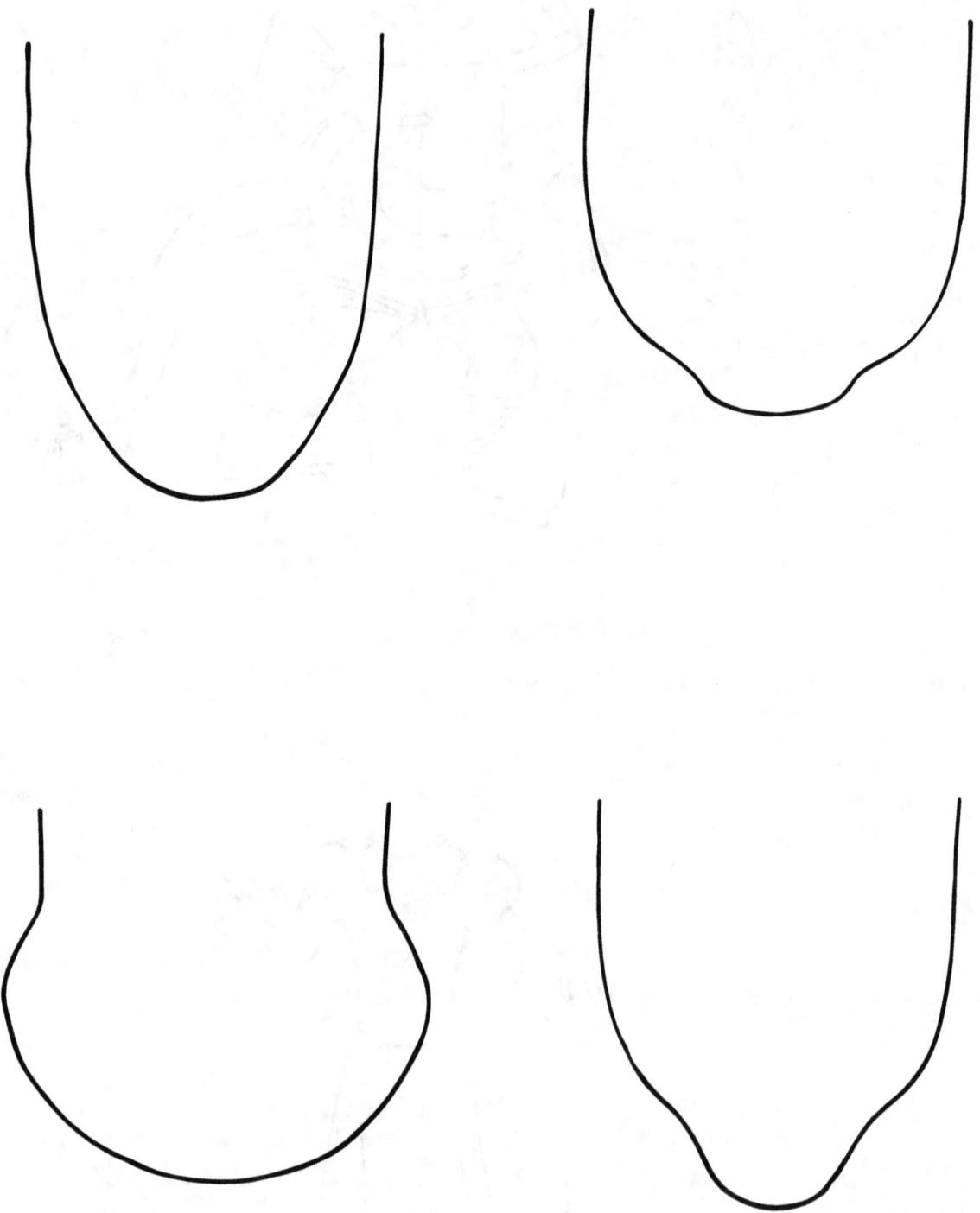

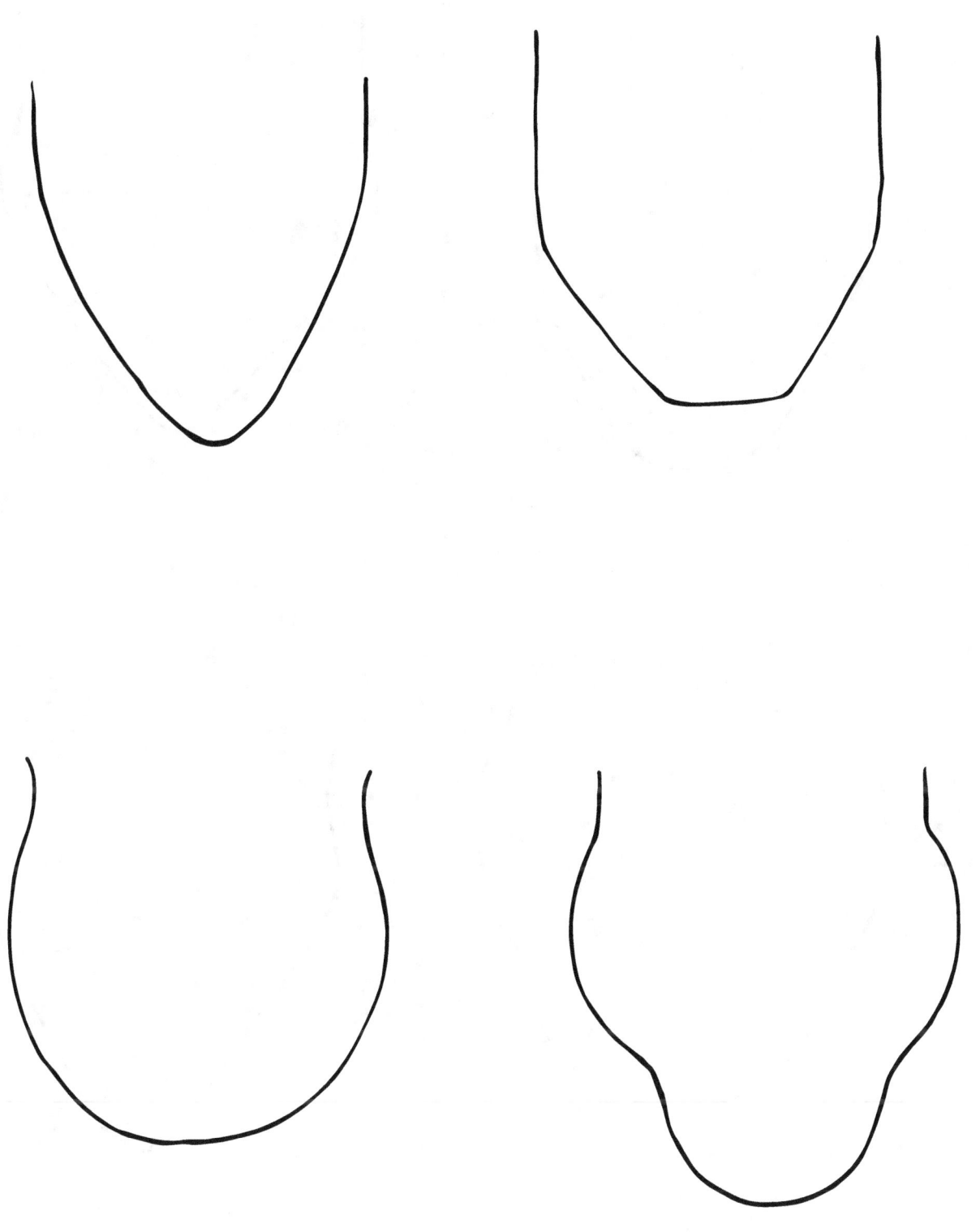

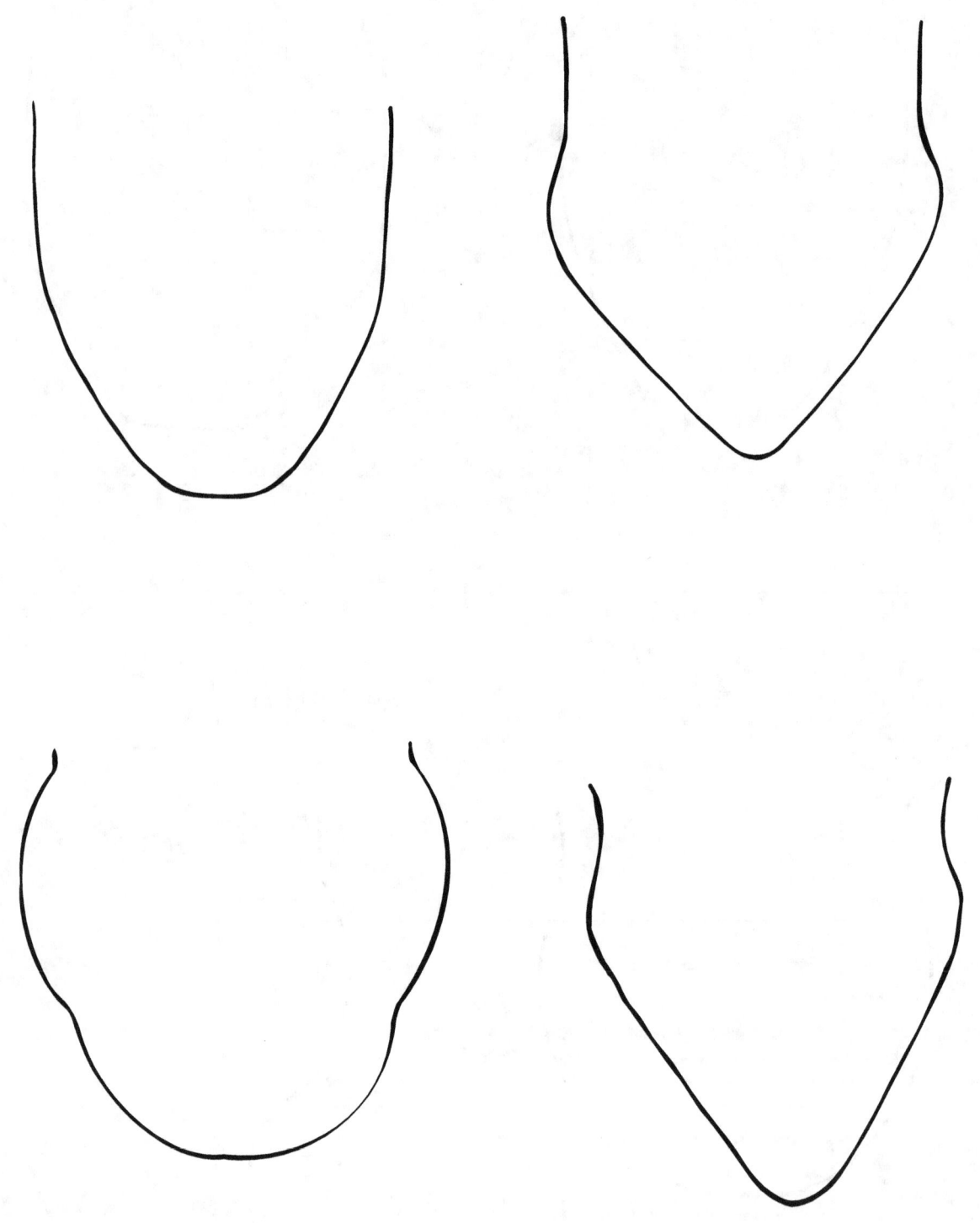

Hair

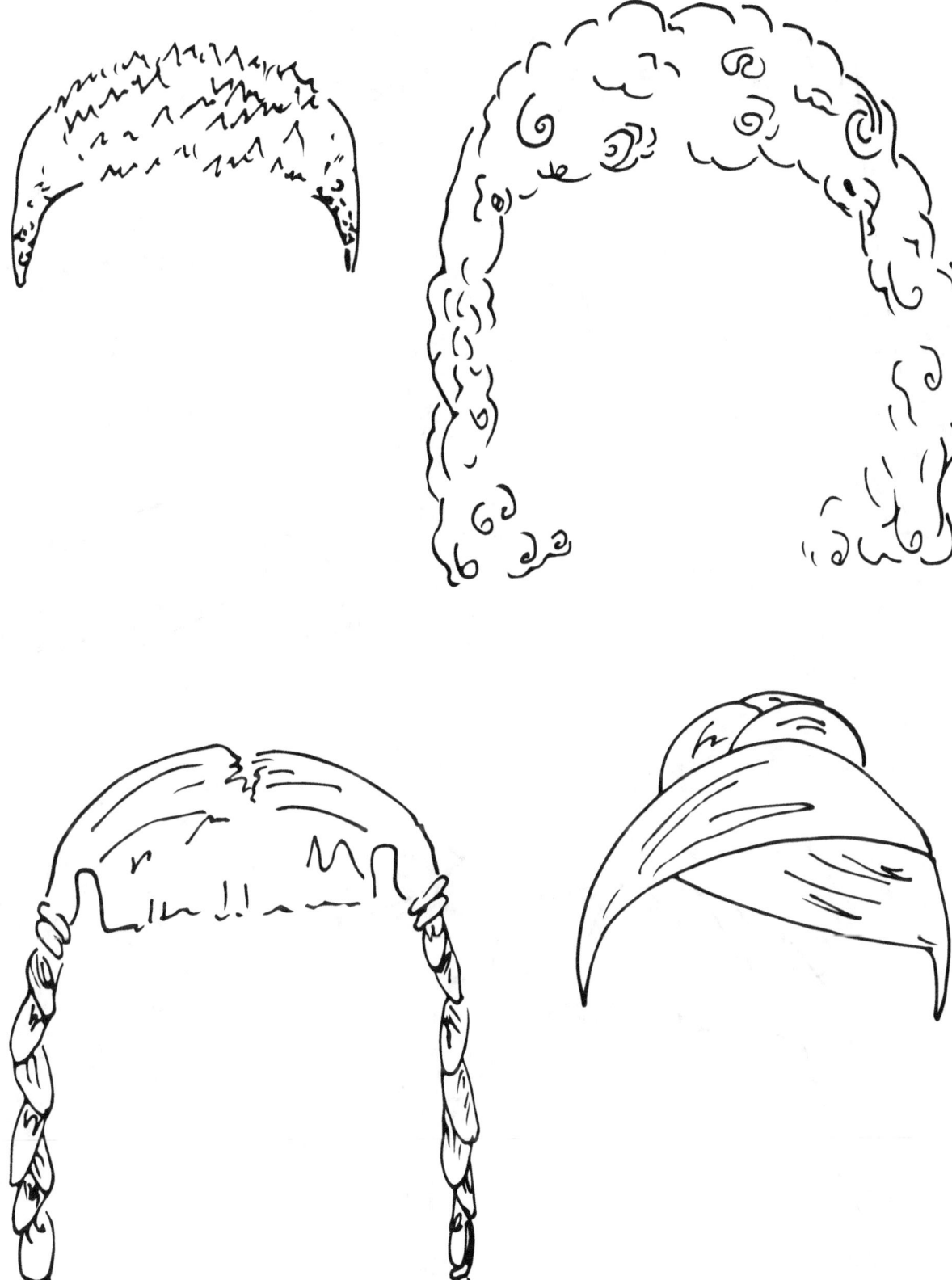

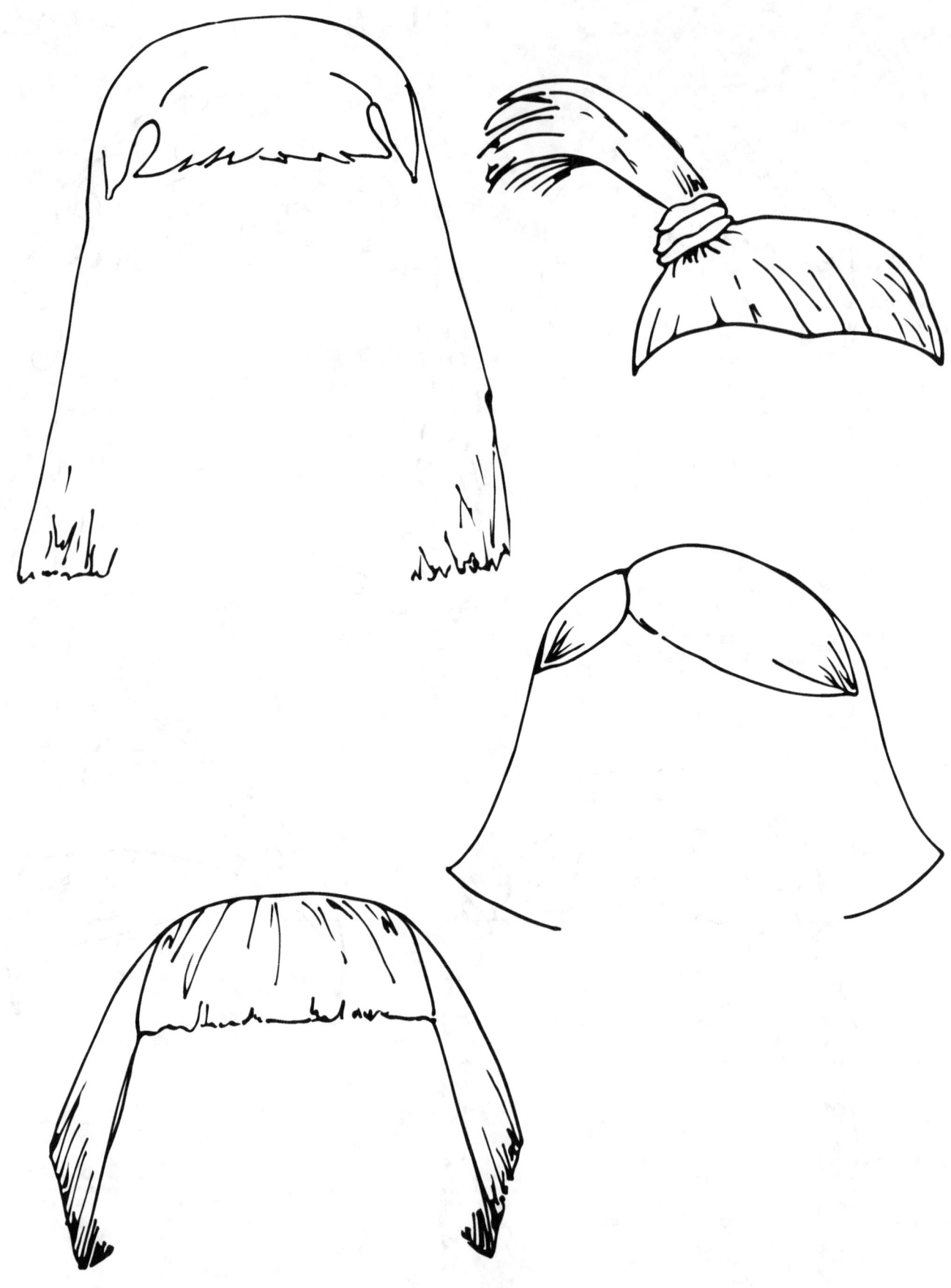

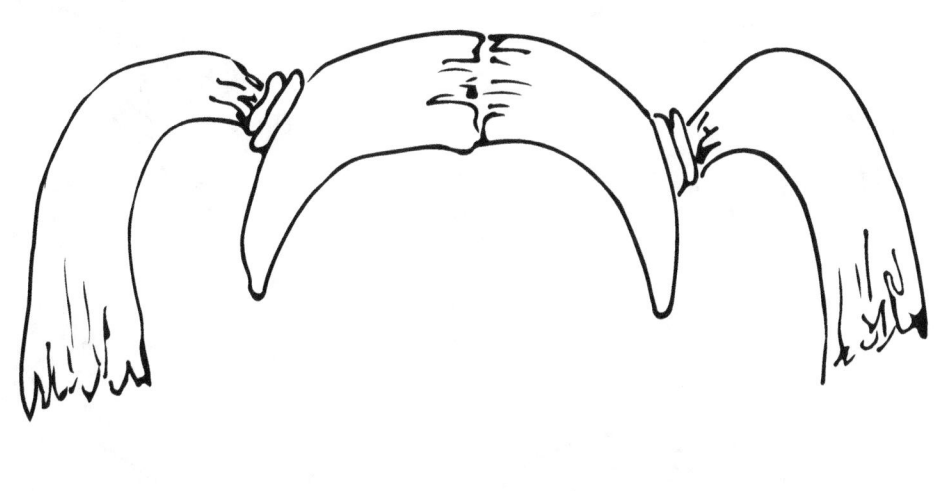

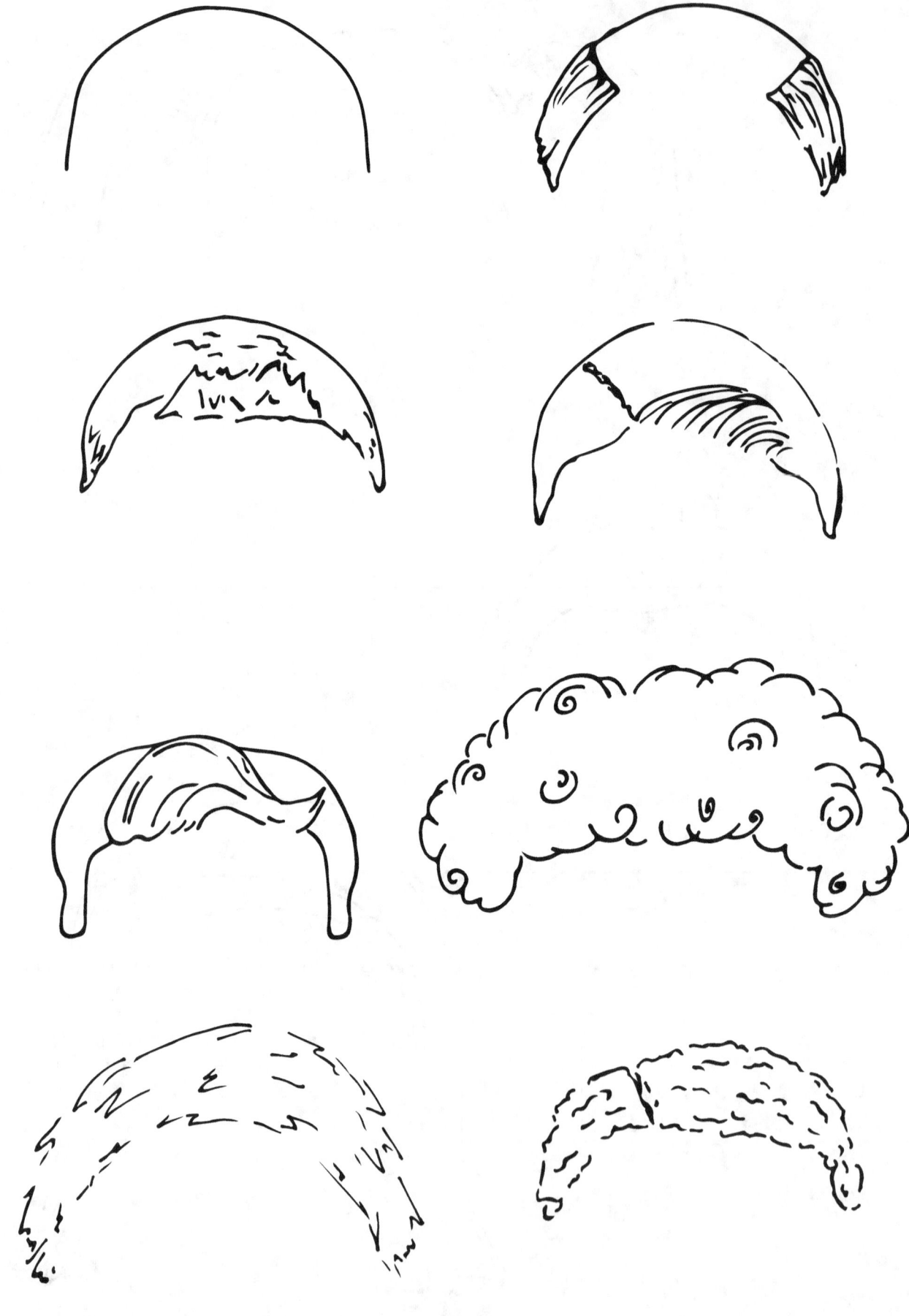

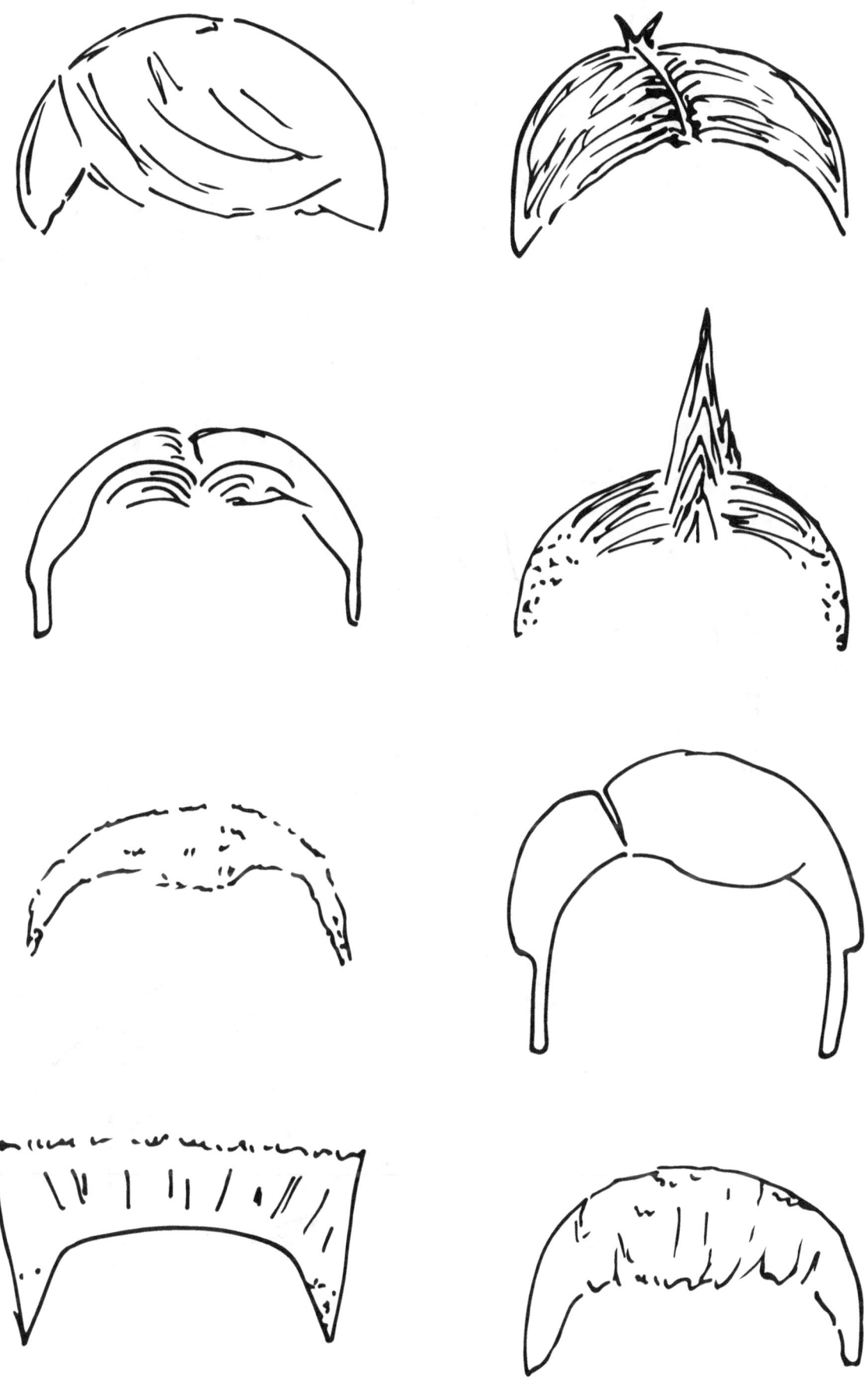

Hats

Ears

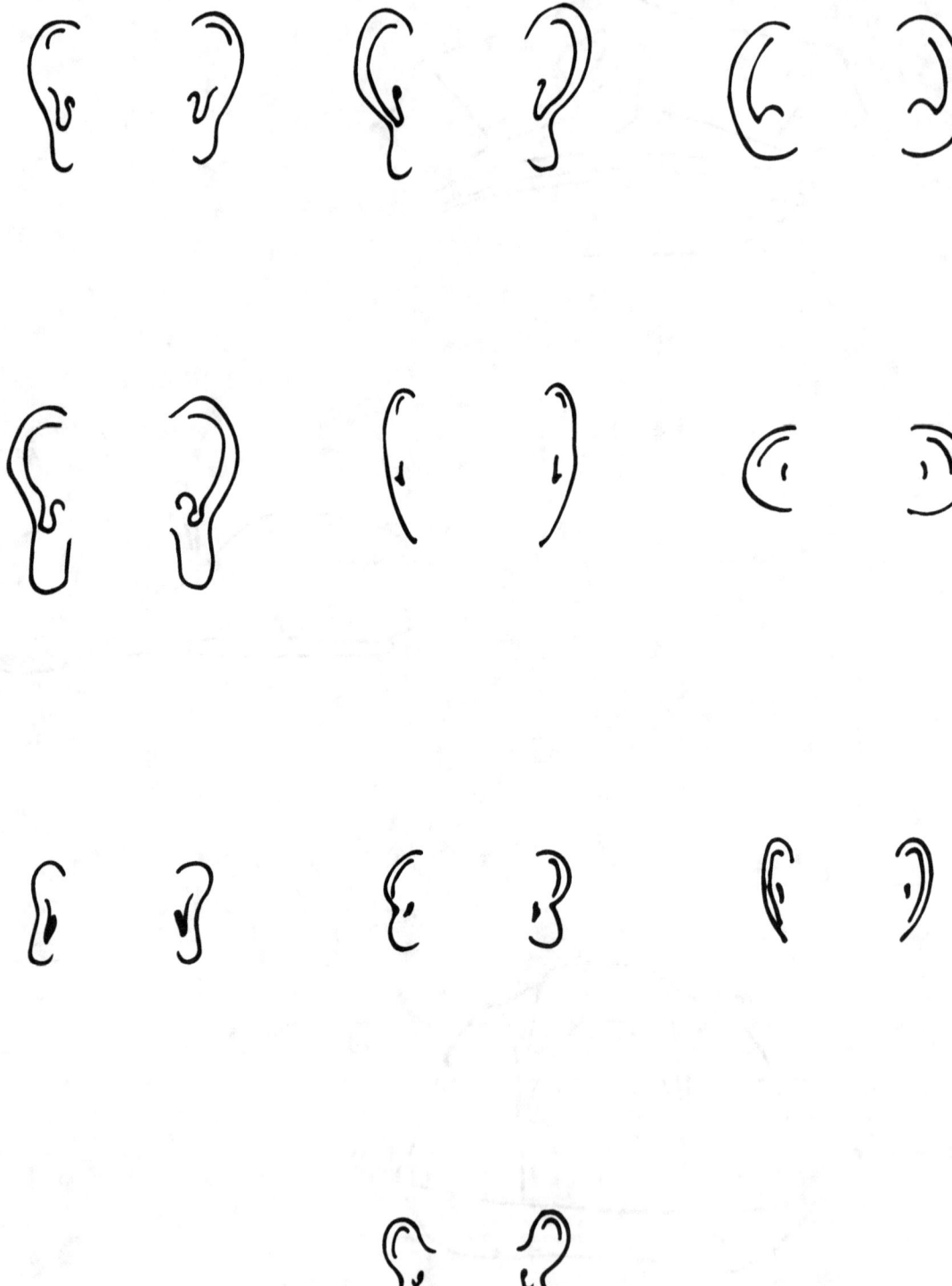

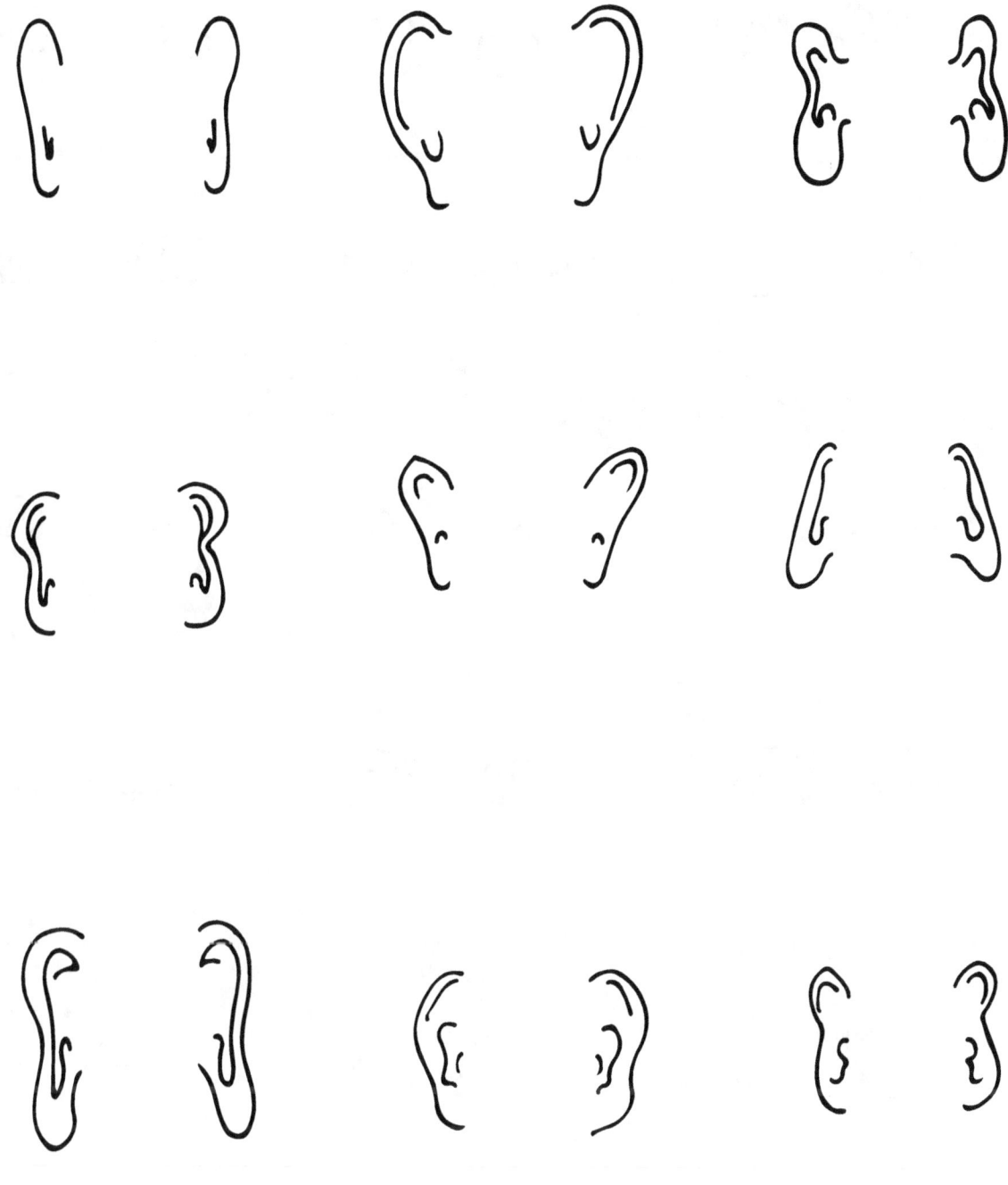

Eyes

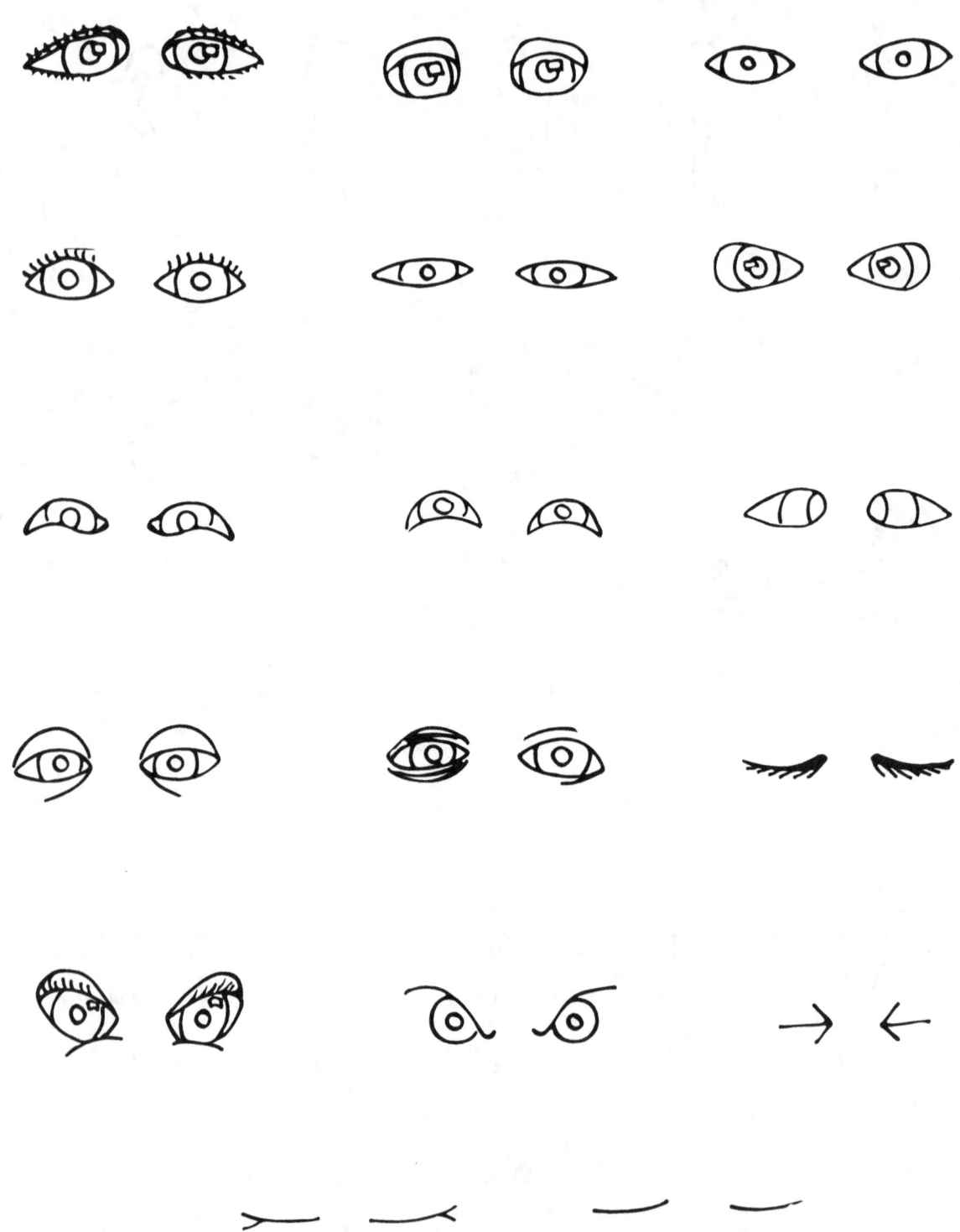

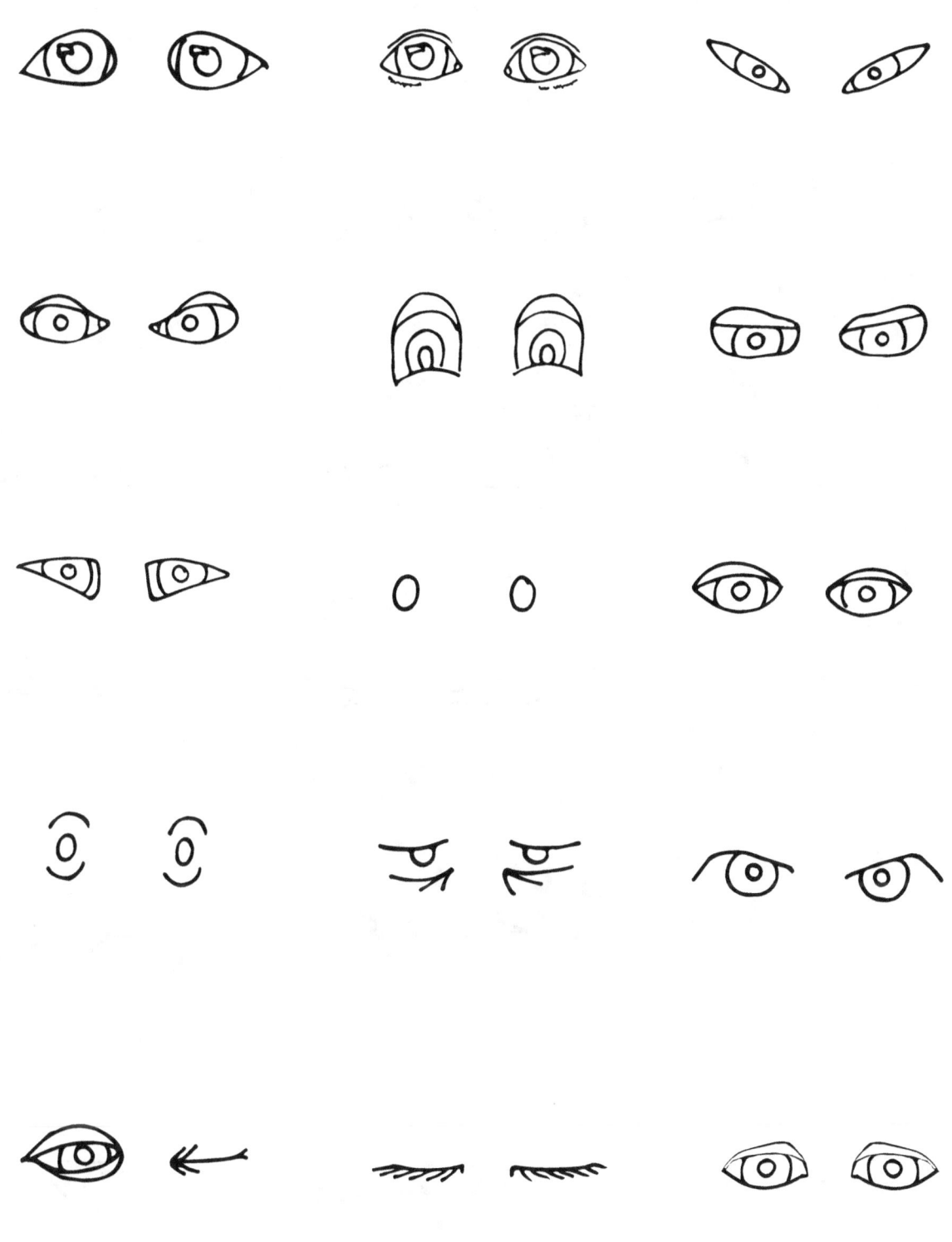

Eyebrows

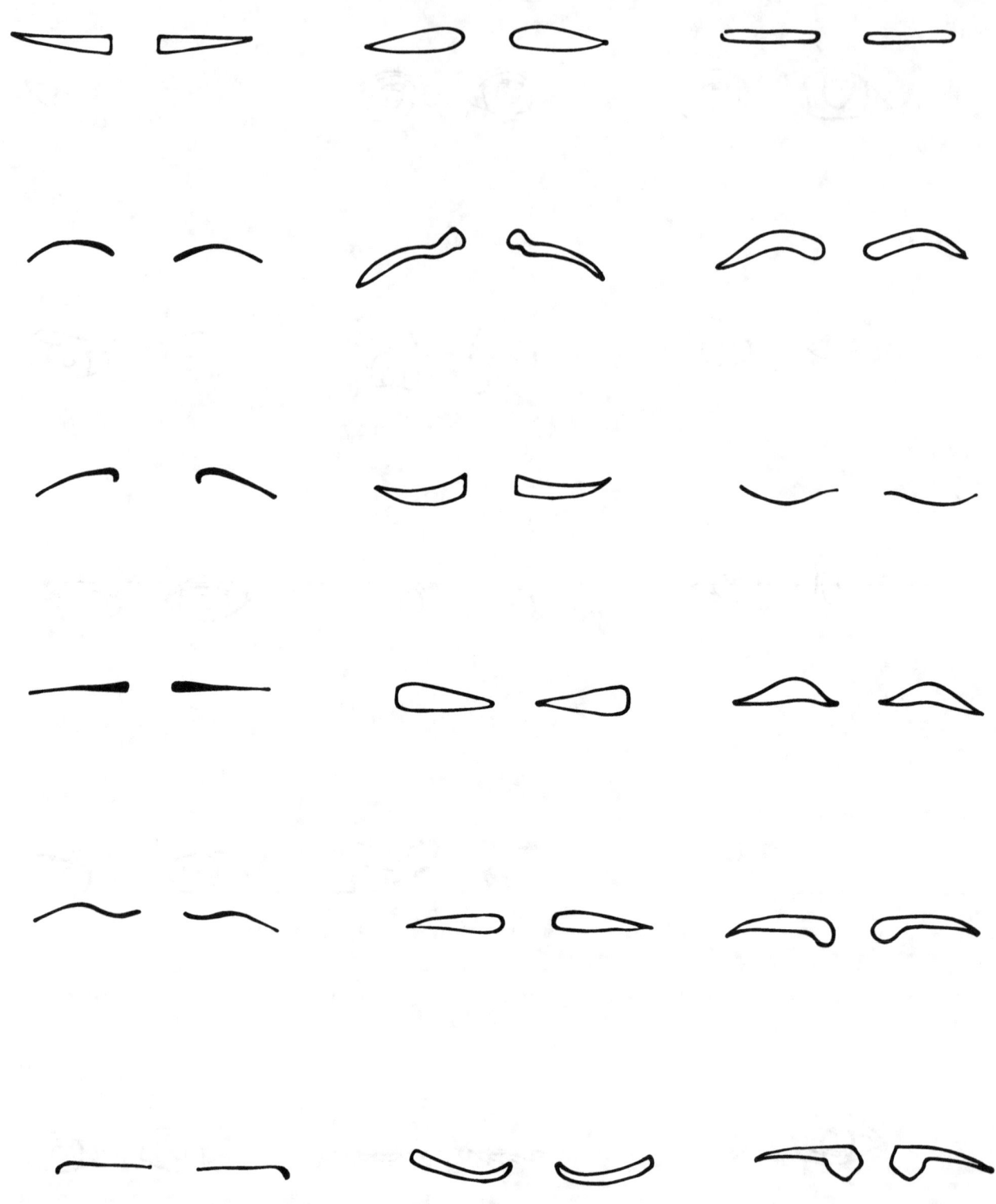

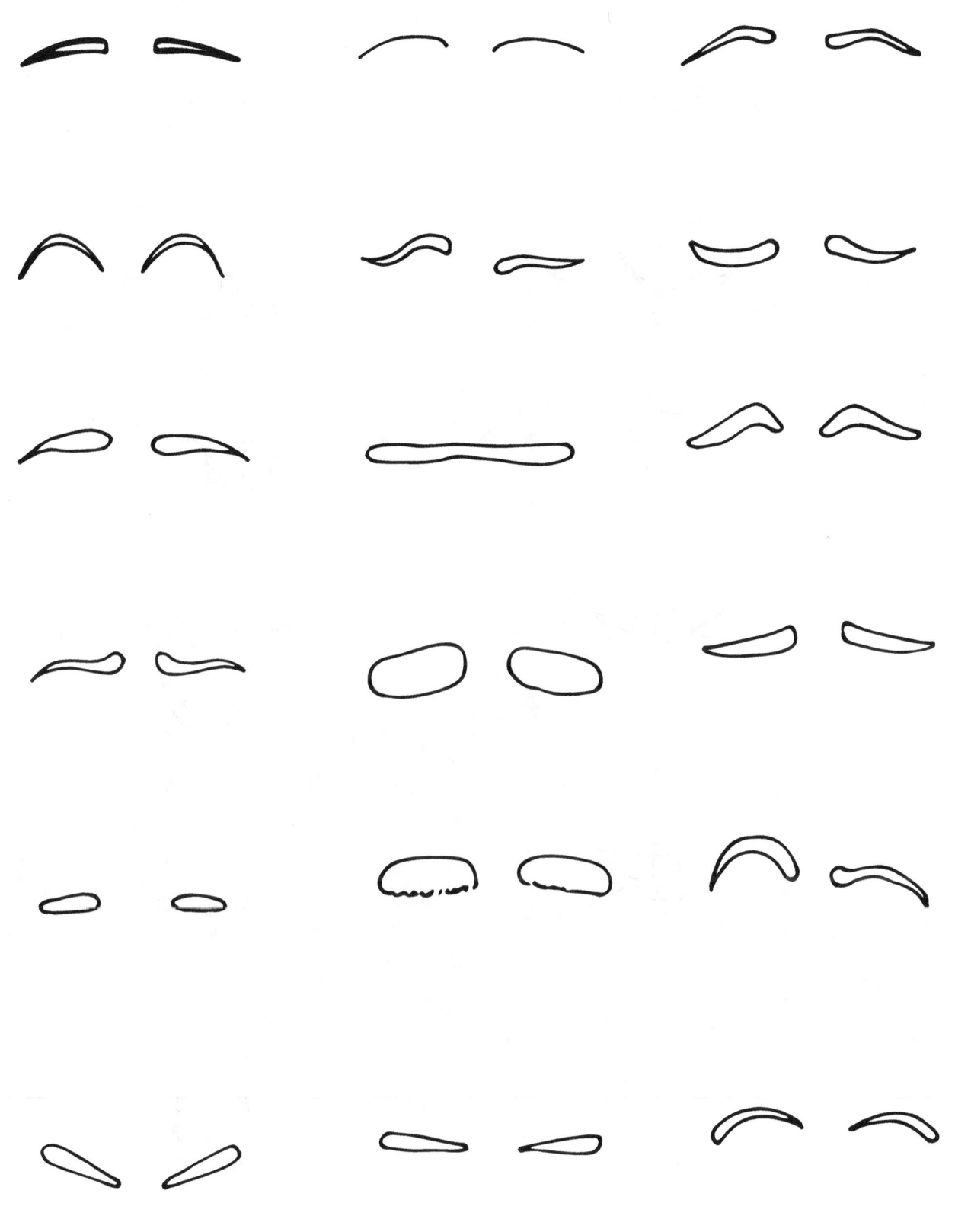

Mouths

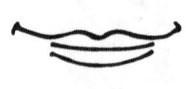
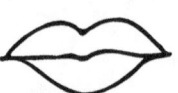

Noses

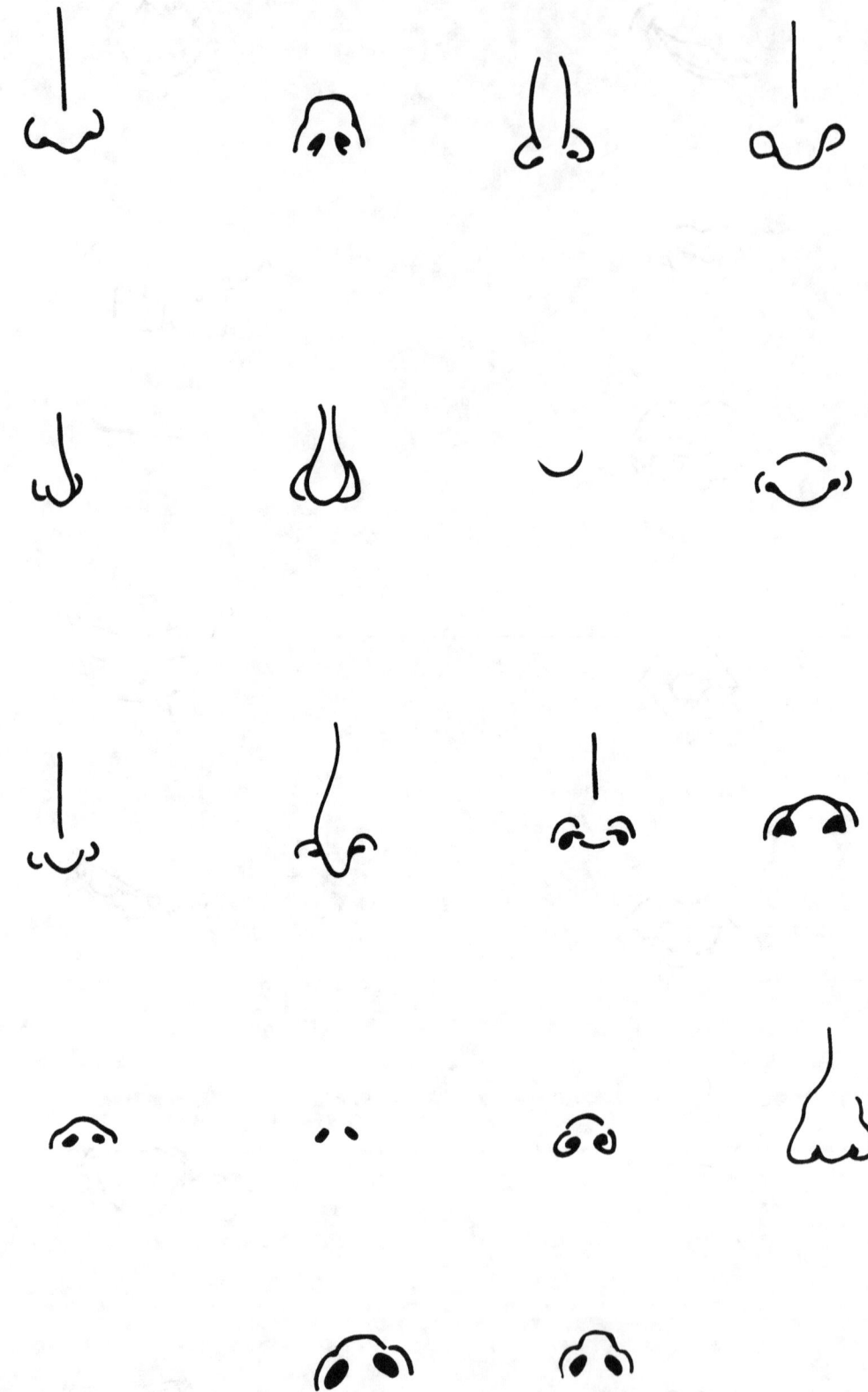

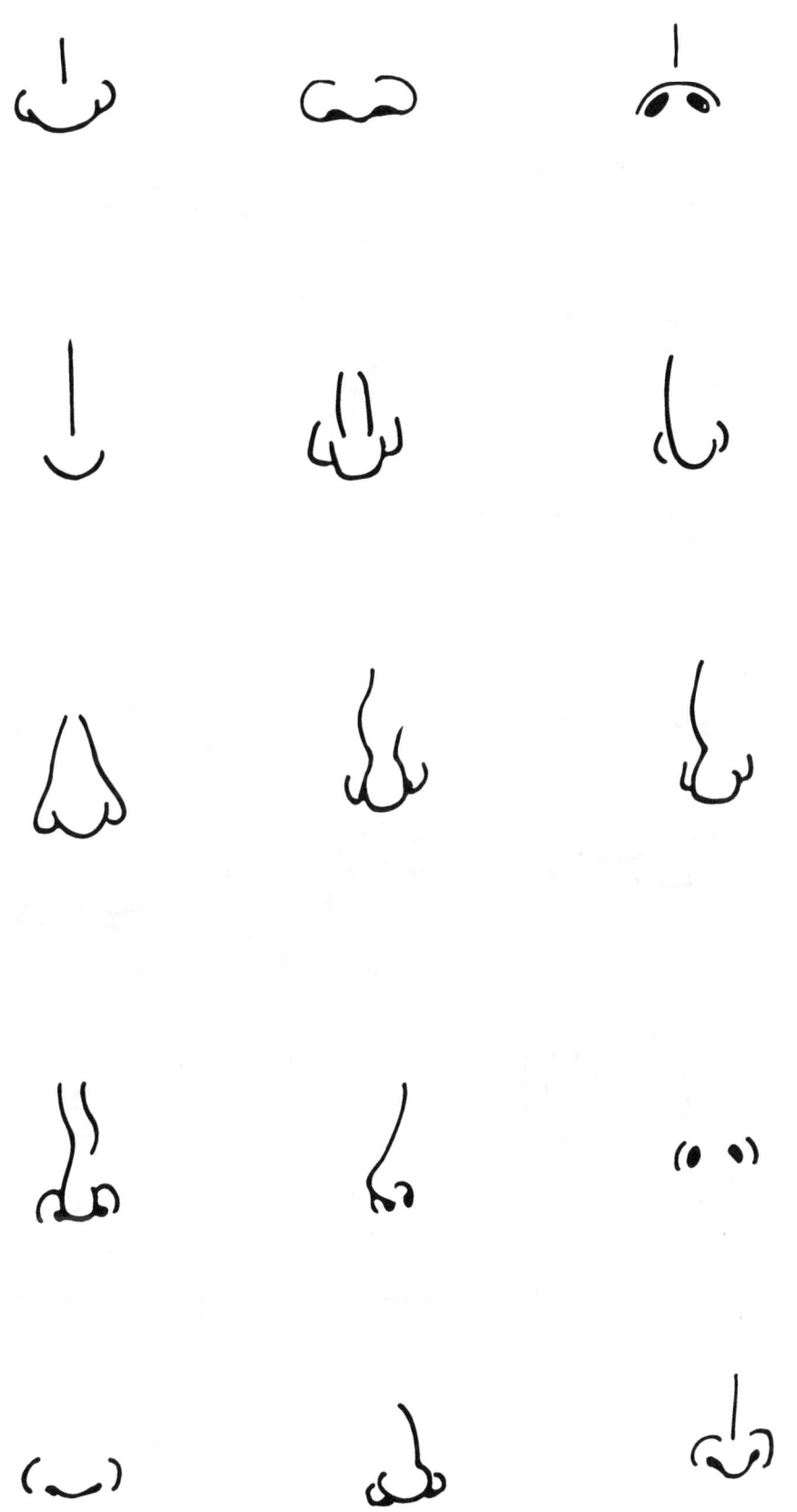

Mustaches

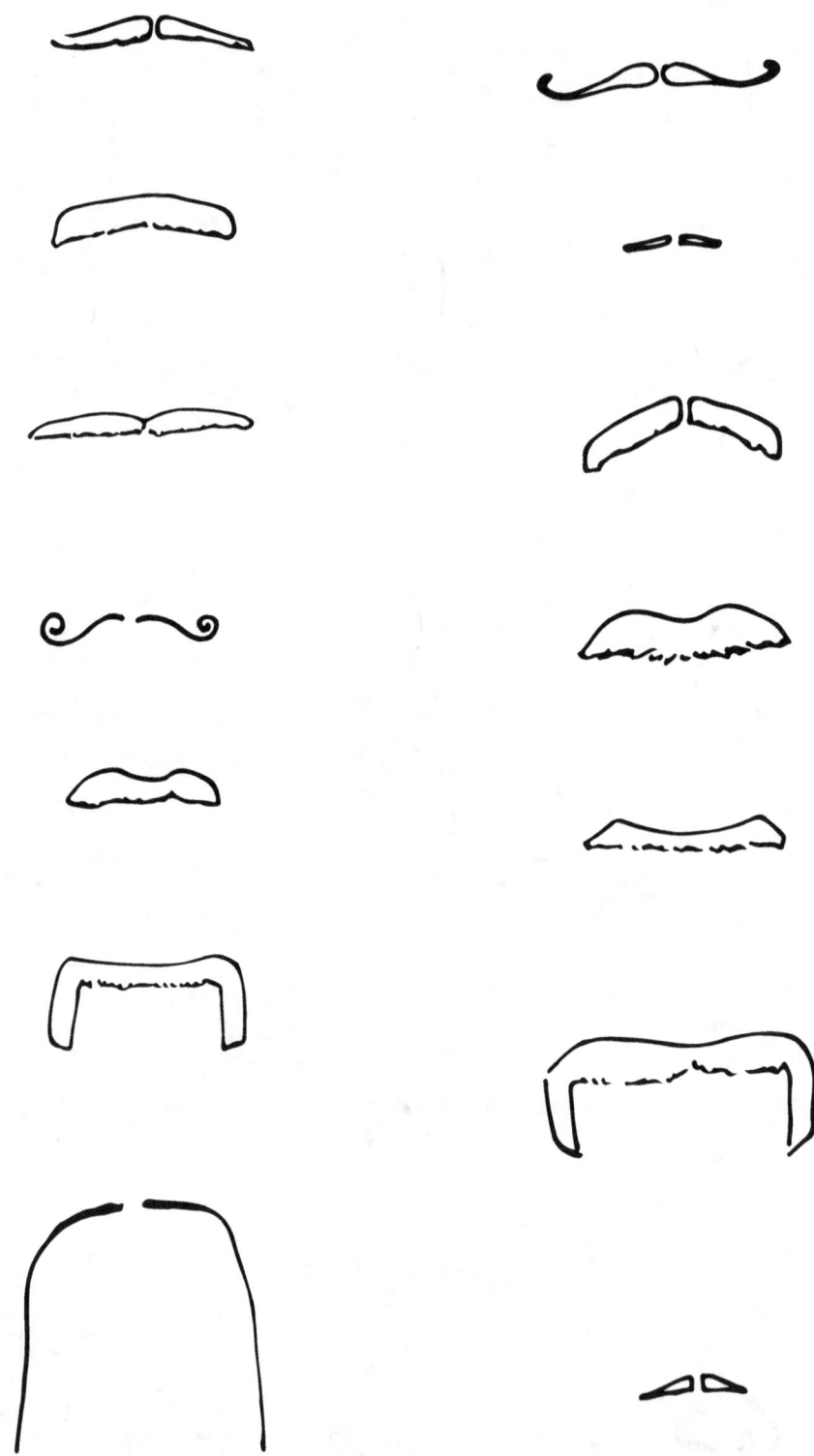

Glasses

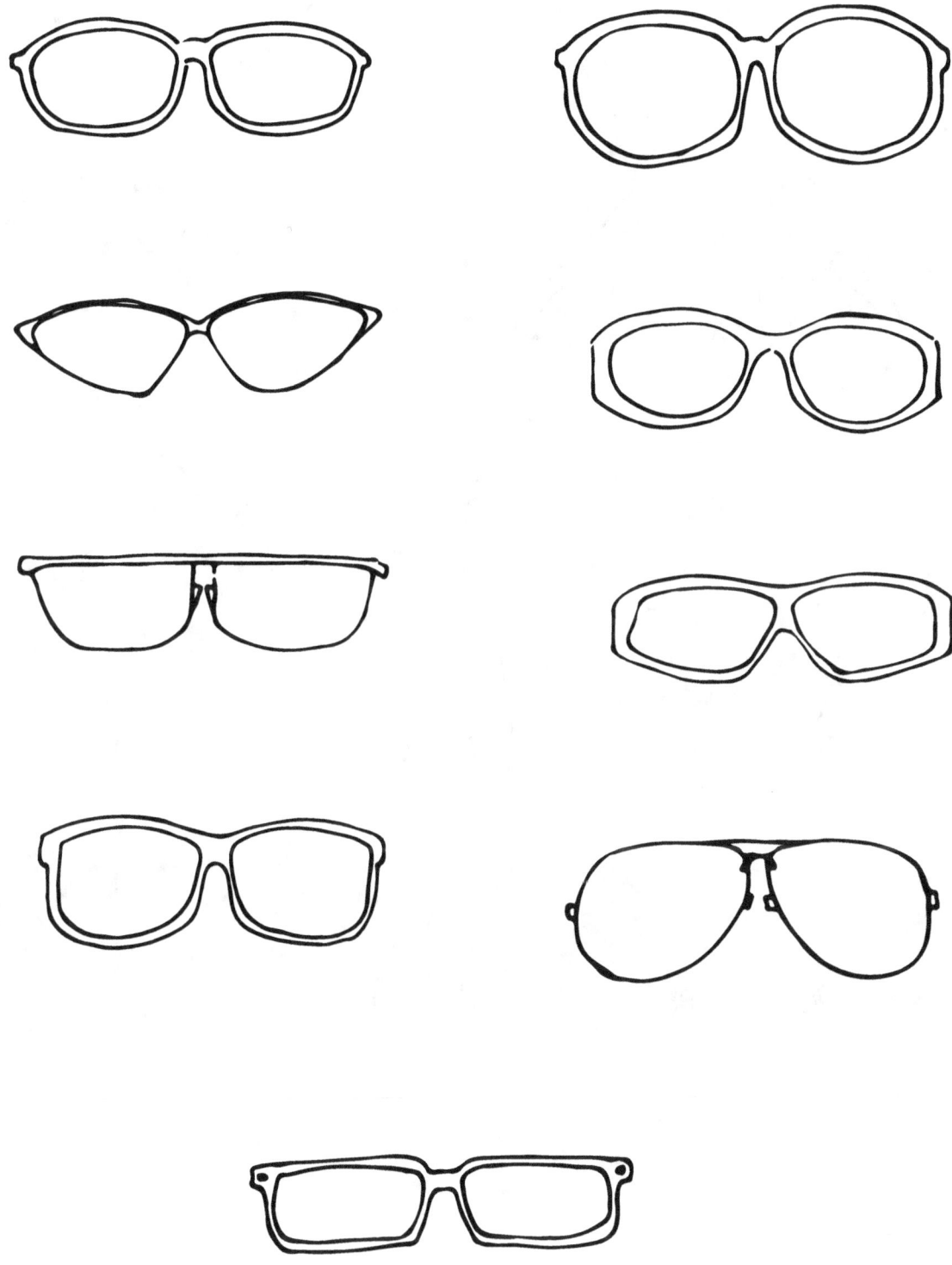

Accessories

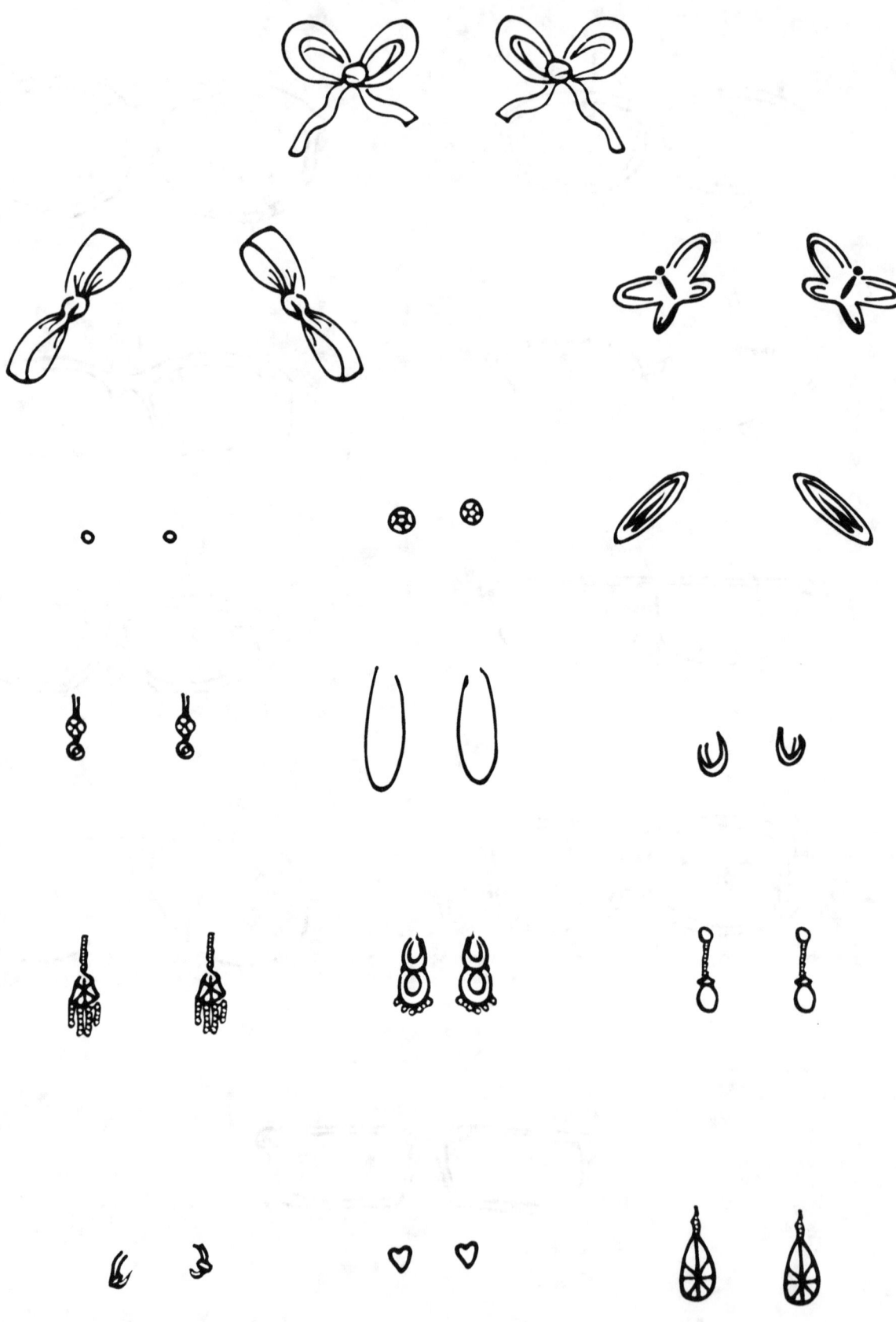

About the Author

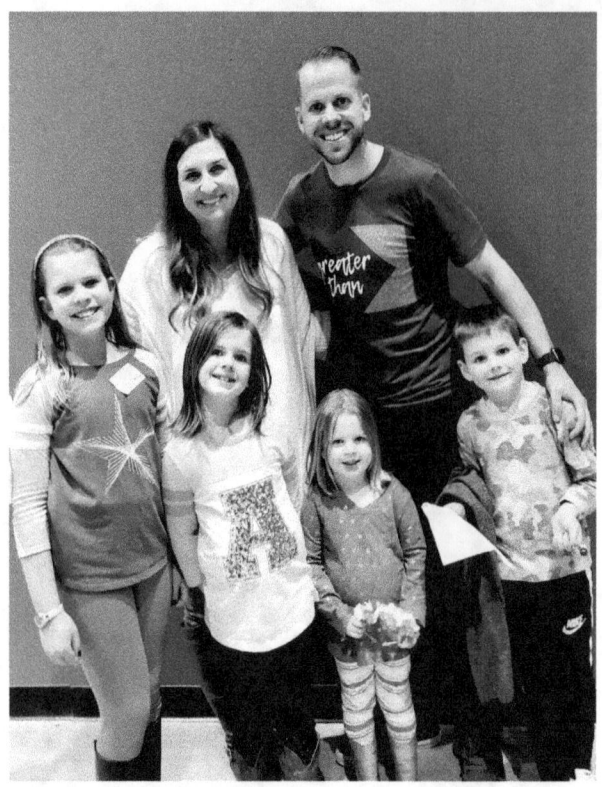

I love my family!!! As a kid I always enjoyed drawing and would often challenge my brothers to drawing competitions. My brothers were way better at art than I was, but my passion for art pushed me to continue to practice and develop my art skill. One of the things I loved drawing was silly cartoons. I took art classes throughout Junior High and High School and went on to graduate from San Jose State University with a degree in art and then graduated from Bethany University with a teaching credential in art. I now use my art to bless others. I have three wonderful daughters, one sweet little boy, and an amazing wife. I'm currently the Lead Pastor at Real Life Christian Church in Cheaspeake, Virginia and I hope that you will find this book to be full of fun, will bring you joy, and that you will discover a love for art .

www.ingramcontent.com/pod-product-compliance
Lightning Source LLC
Chambersburg PA
CBHW081801170526

45167CB00008B/3281